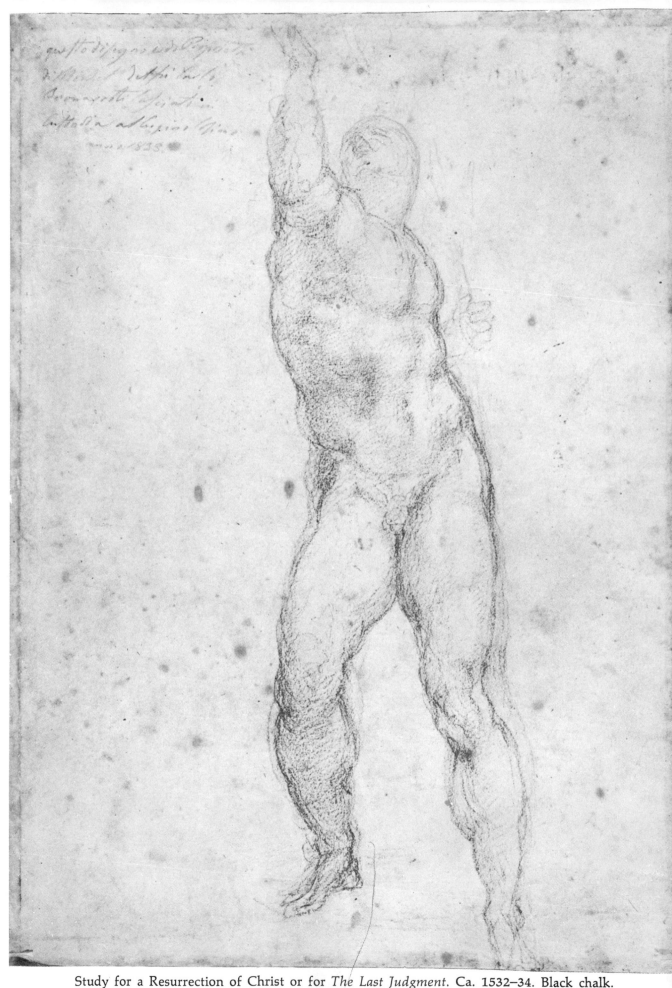

Study for a Resurrection of Christ or for *The Last Judgment*. Ca. 1532–34. Black chalk. 418 x 288 mm. Casa Buonarroti, Florence (65F verso).

MICHELANGELO
LIFE DRAWINGS
46 Works by
Michelangelo Buonarroti

Dover Publications, Inc., New York

Publisher's Note

The life drawings by Michelangelo Buonarroti (1475–1564) selected for this volume were created over a sixty-year period of his amazing career. Representing most of his artistic themes and most of his drawing media and techniques, they range from his youthful studies after ancient sculpture and early Renaissance frescos to the otherworldly religious compositions of his old age. Included are preliminary drawings related to many of his important commissions: among others, the marble *David* of 1501–04; the famous cartoon of 1504 for the projected fresco in the Palazzo Vecchio, *The Battle of Cascina*; the paintings on the vaulted ceiling of the Sistine Chapel, executed 1508–12; and the imposing fresco of *The Last Judgment* in the same chapel, 1535–41; as well as several of the more highly finished allegorical presentation drawings of the early 1530s. In some cases, especially that of *The Battle of Cascina*, the preliminary drawings are all that remain to testify to a lost masterpiece.

Over the years Michelangelo scholars have been sharply divided with regard to the authenticity of many important drawings; several of the works included here have been called into doubt, but none of them has lacked for staunch defenders in recent years. The dating of many pieces also arouses controversy; the dates given here, sometimes allowing a considerable range of years for the creation of a single sheet, incorporate the judgments of a number of scholars. The dimensions are given in millimeters, height before width. The number in parentheses following the name of the present owning institution is the inventory number of the respective drawing within that institution's collection.

Published in Canada by General Publishing Company,
Ltd., 30 Lesmill Road, Don Mills, Toronto, Ontario.

Michelangelo Life Drawings, first published by Dover Publications, Inc., in 1979, is a new selection of drawings reproduced from a variety of published sources.
The captions and Publisher's Note have been prepared specially for the present edition.

International Standard Book Number: 0-486-23876-8
Library of Congress Catalog Card Number: 79-53018

Manufactured in the United States of America
Dover Publications, Inc.
180 Varick Street
New York, N.Y. 10014

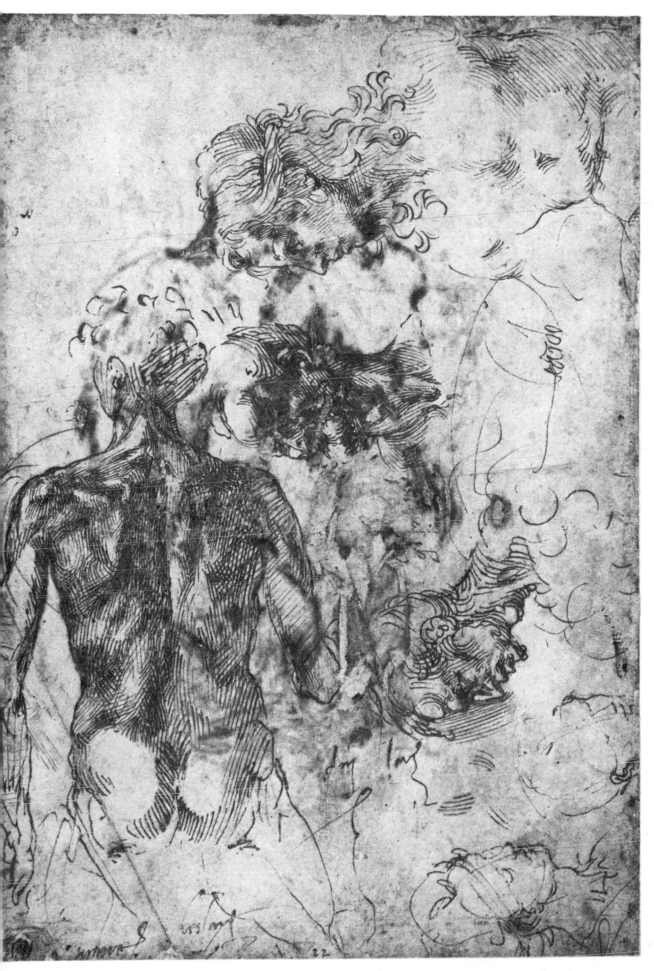

1. Studies of torsos and heads. Ca. 1501–05. Pen and ink. 254 x 168 mm. Ashmolean Museum, Oxford (22 verso).

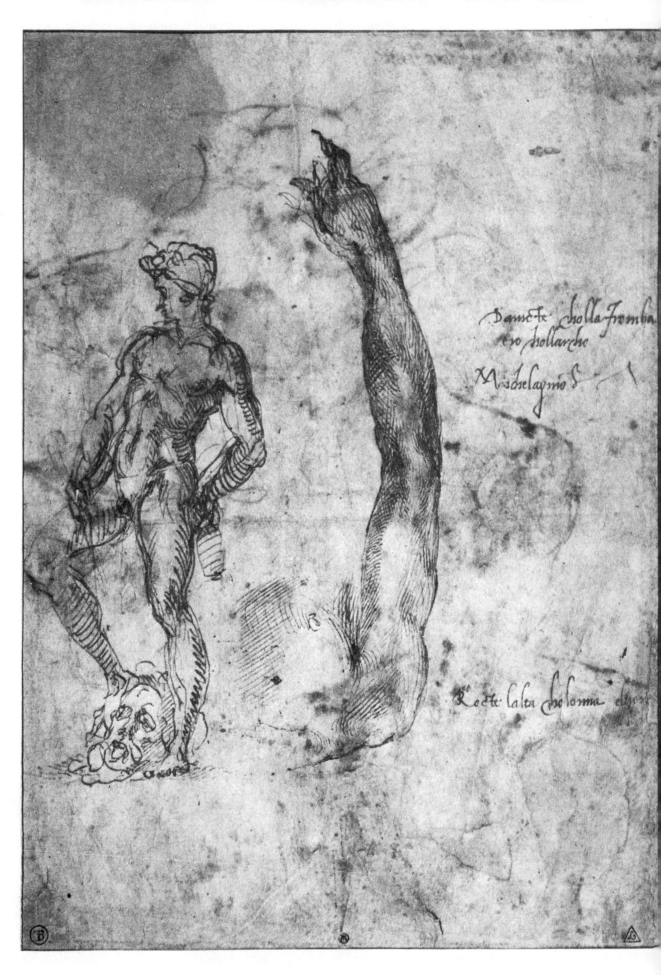

2. Study for an arm of the marble *David* and the figure of the bronze *David*. 1501–03.
 Pen and ink. 265 x 188 mm. Louvre, Paris (714 recto).

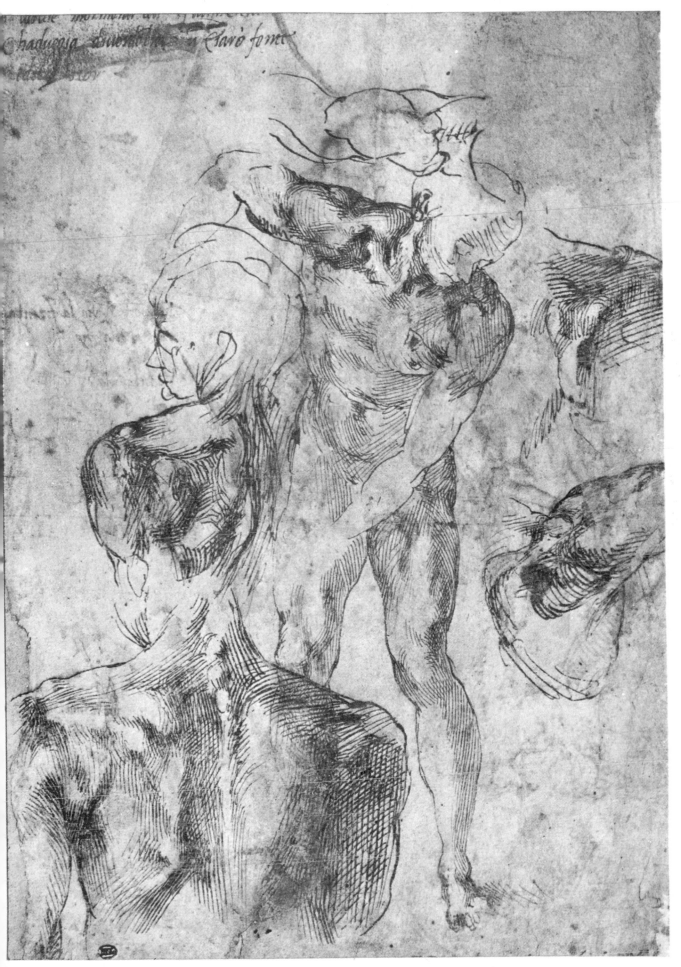

3. Man digging, and other figure studies. Ca. 1501. Pen and ink. 265 x 188 mm. Louvre, Paris (714 verso).

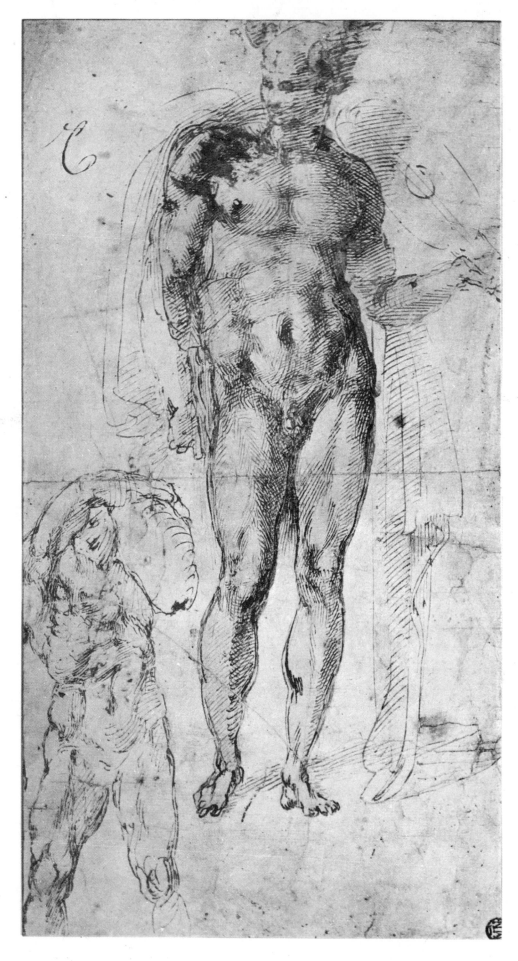

4. Mercury (with overdrawing transforming it into an Apollo), and another nude study. Ca. 1500–02. Pen and ink. 399 x 210 mm. Louvre, Paris (688 recto).

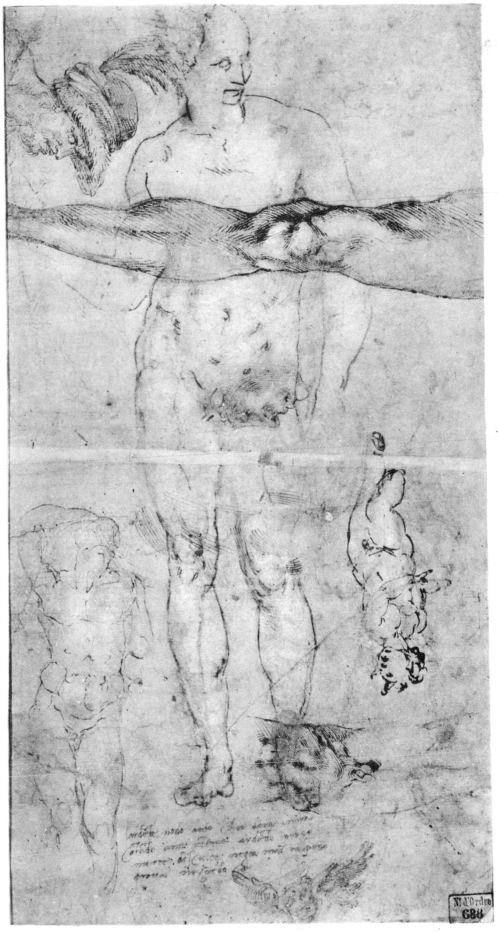

5. Various studies, including a tracing of the Mercury-Apollo from the other side of the sheet. Ca. 1500–06. Pen and ink. 399 x 210 mm. Louvre, Paris (688 verso). Only the putto and the captive are definitely by Michelangelo.

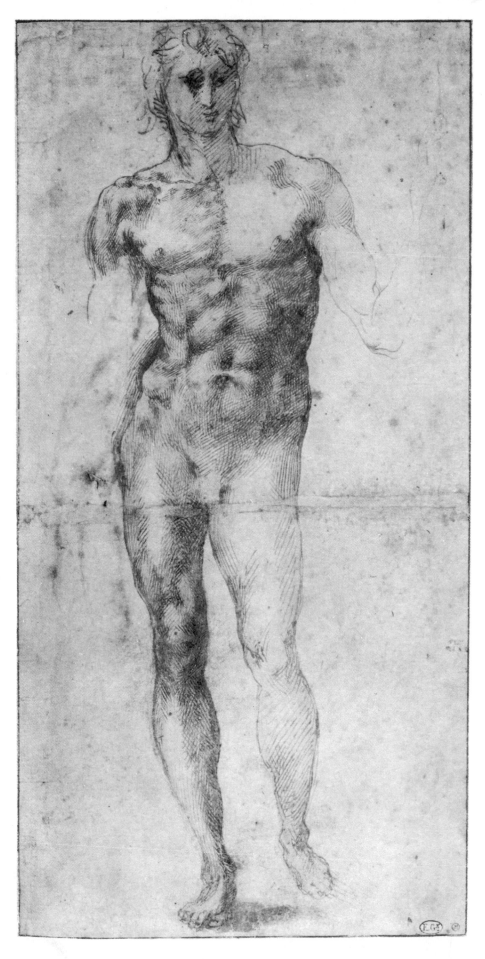

6. Male nude. Between 1496 and 1504. Pen and ink. 340 x 168 mm. Louvre, Paris
(R.F. 70-1068 verso).

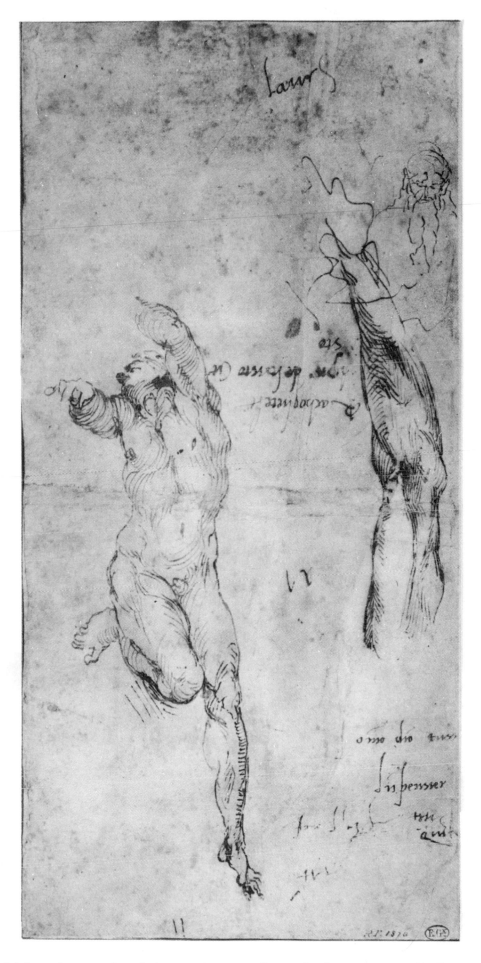

7. Male nude; arm; bearded man. Ca. 1504. Pen and ink. 340 x 168 mm. Louvre, Paris
 (R.F. 70-1068 verso).

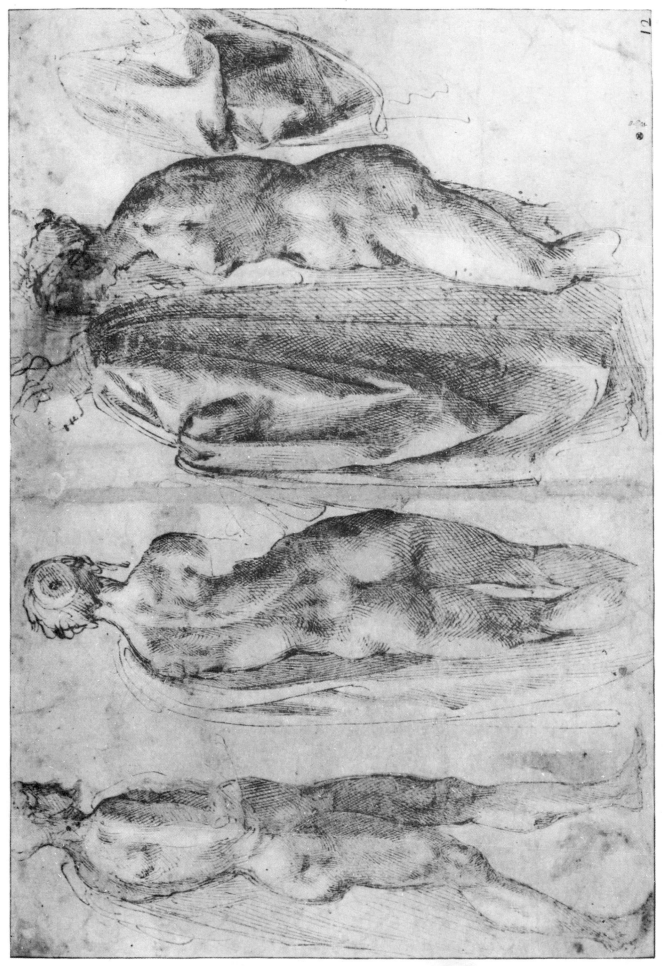

8. Figure studies from antique sculpture (the draped figures perhaps from frescos).

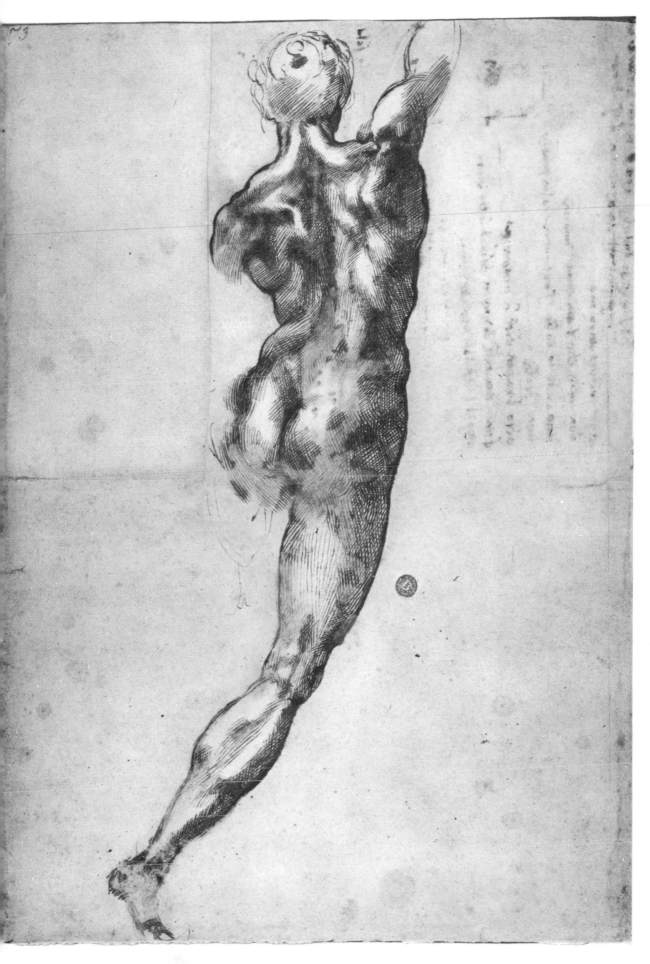

9. Male nude, study for *The Battle of Cascina*. Ca. 1504. Pen and ink with traces of black chalk. 408 x 284 mm. Casa Buonarroti, Florence (73F recto).

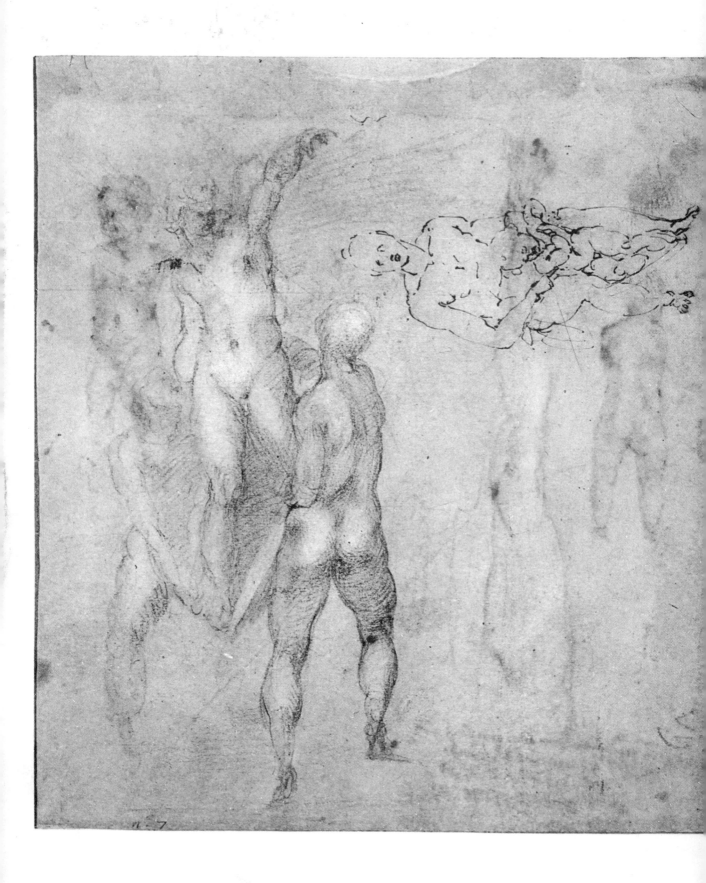

10. Three nude men (study for *The Battle of Cascina*?); sketch for the *Bruges Madonna*.
Ca. 1504. Black chalk; pen and ink. 315 x 278 mm. British Museum, London (1859-6-
25-564 recto).

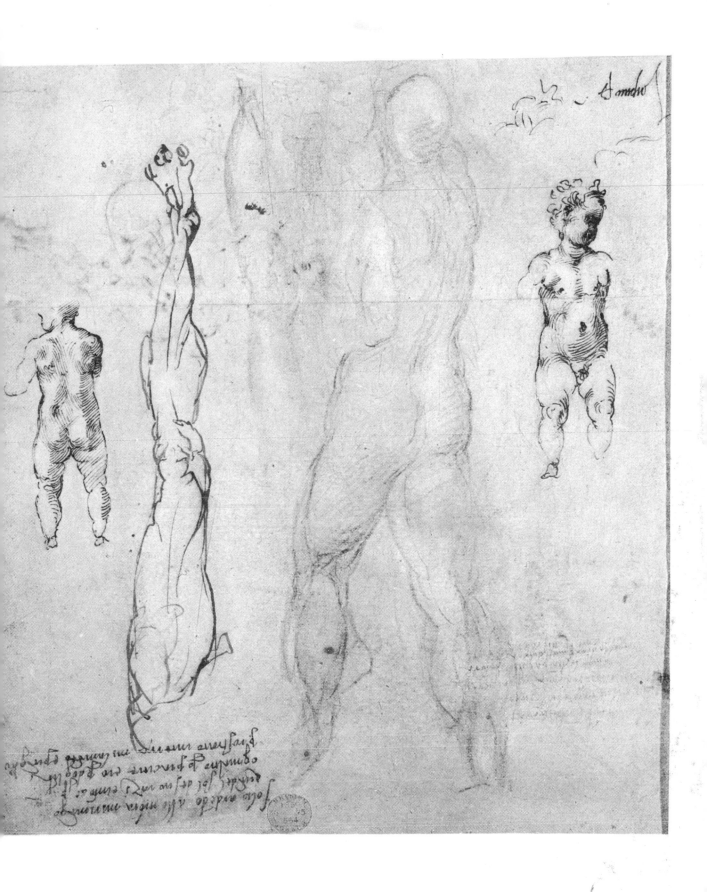

11. Various figure studies. Ca. 1504. Black chalk; pen and ink. 315 x 278 mm. British
Museum, London (1859-6-25-564 verso).

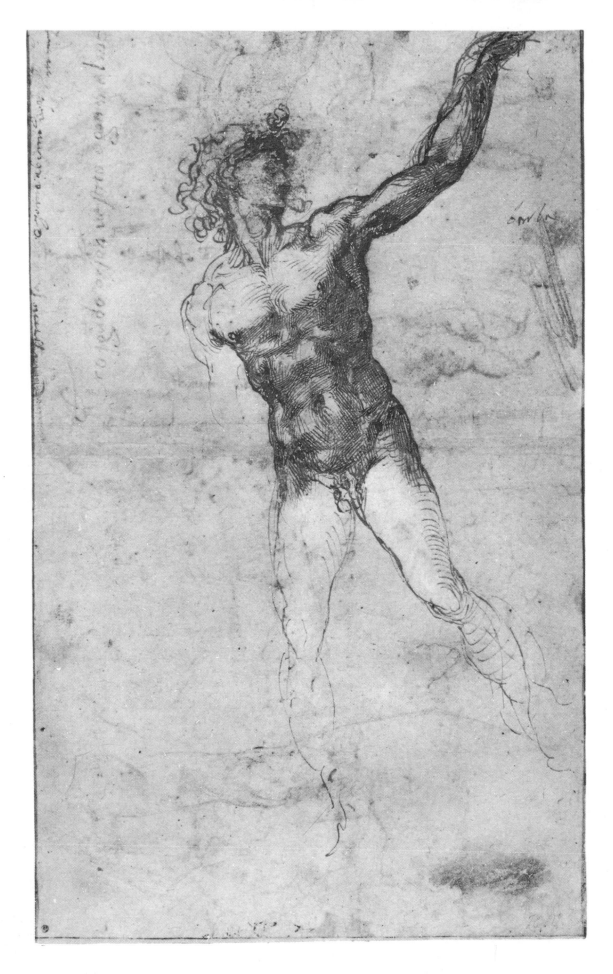

12. Male nude, study for *The Battle of Cascina*. Ca. 1504. Pen and ink. 375 x 230 mm. British Museum, London (1887-5-2-117 recto).

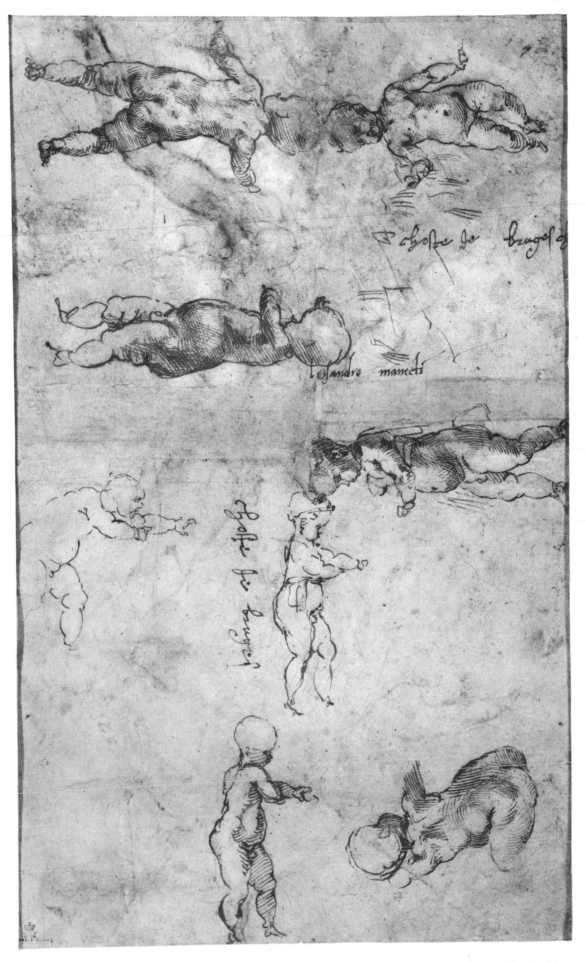

13. Eight studies of a little boy, perhaps related to the *Bruges Madonna* or the *Taddei Madonna*. Ca. 1504–05. Pen and ink. British Museum, London (1887-5-2-117 verso).

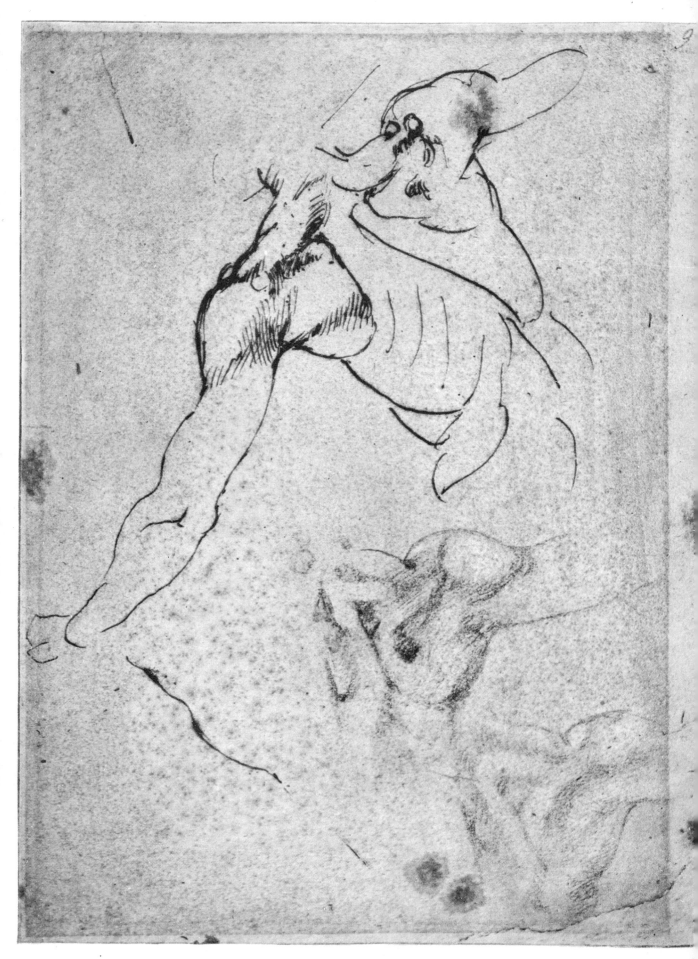

14. Studies of a torso for *The Battle of Cascina*. Ca. 1504. Pen and ink; black chalk. 284 x 210 mm. Casa Buonarroti, Florence (9F).

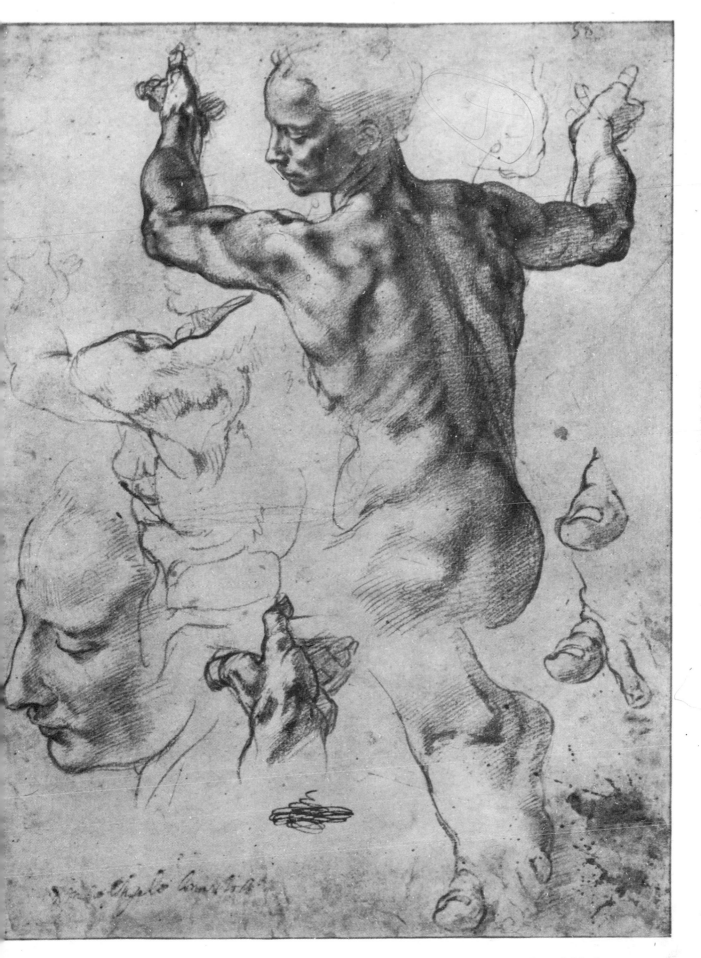

15. Studies for the Libyan Sibyl of the *Sistine Ceiling*. Ca. 1511–12. Red and black chalk. 288 x 313 mm. Metropolitan Museum, New York.

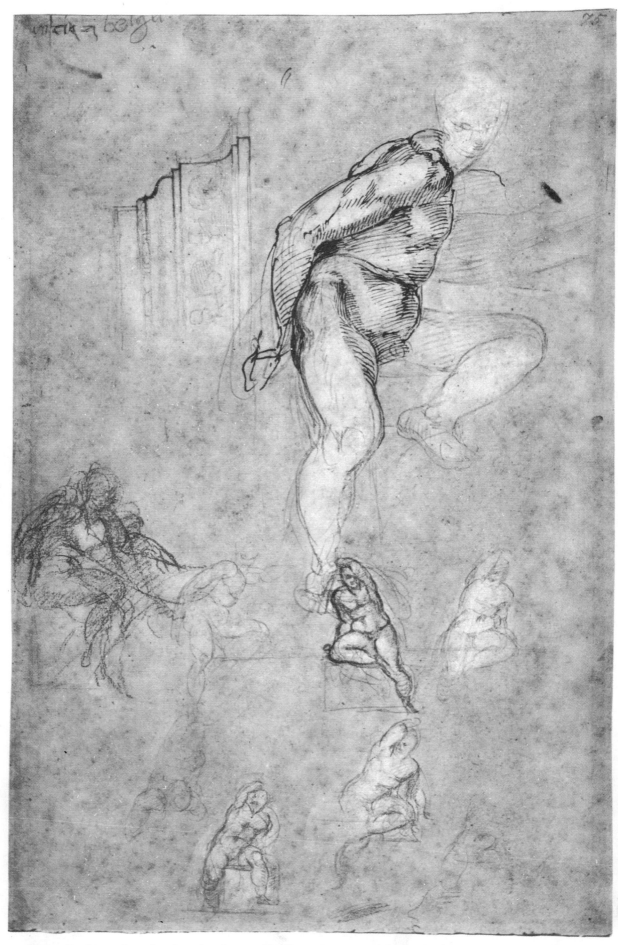

16. Studies of nudes for the *Sistine Ceiling*. Ca. 1509. Black chalk; pen and ink. 414 x 270 mm. Casa Buonarroti, Florence (75F).

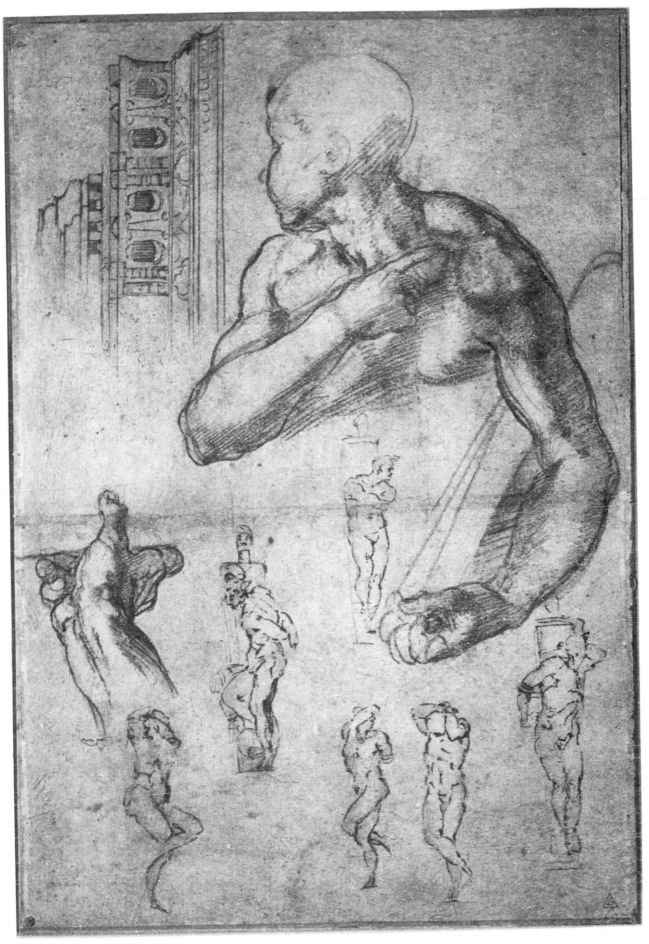

17. Studies for the Libyan Sibyl complex of the *Sistine Ceiling* and for the *Tomb of Julius II*. Ca. 1510–13. Red chalk; pen and ink. 286 x 194 mm. Ashmolean Museum, Oxford (23 recto).

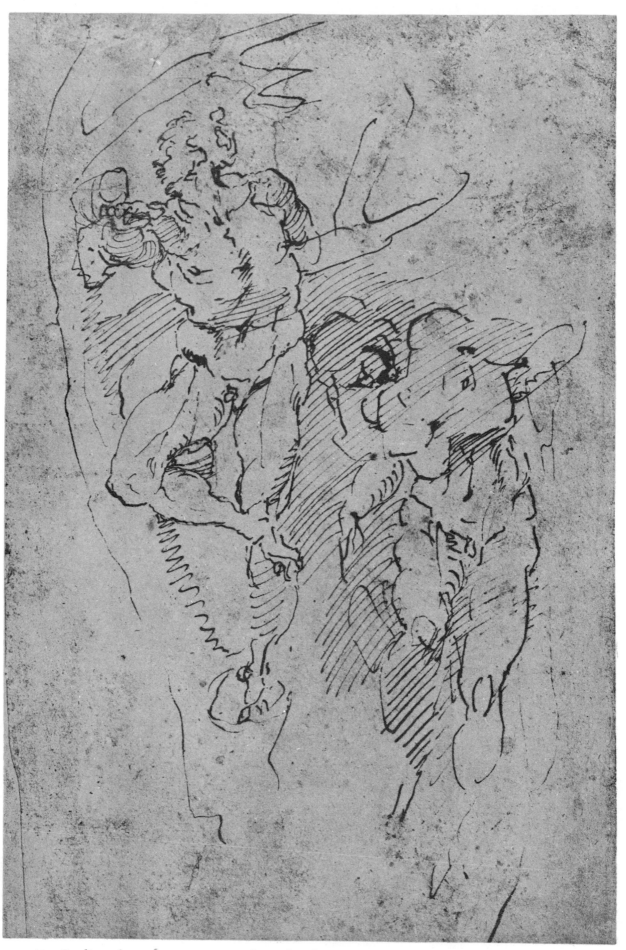

18. Studies of men in torment, perhaps for the crucified Haman of the *Sistine Ceiling*.
Ca. 1511–24. Pen and ink. 249 x 160 mm. British Museum, London (1859-6-25-555).

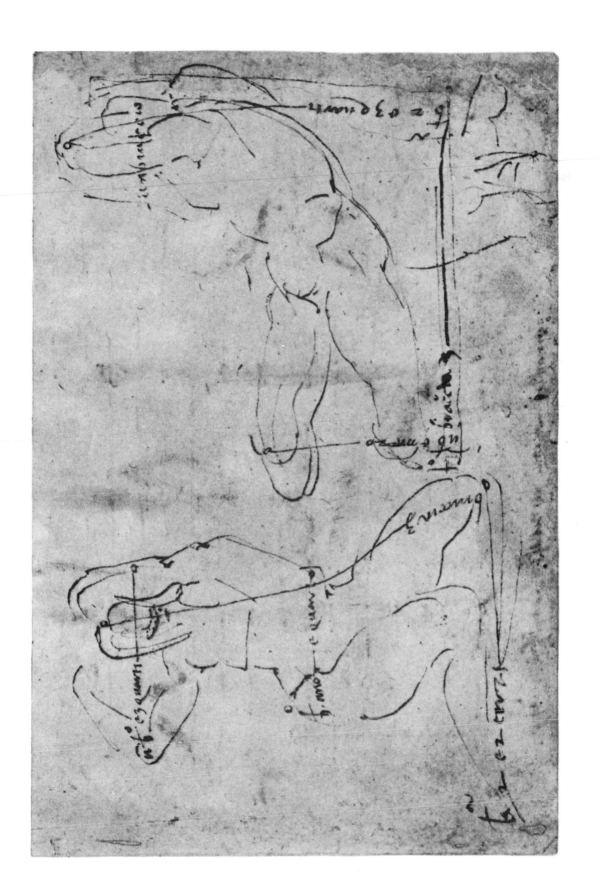

19. Three sketches for a river god in the *Medici Chapel*. Ca. 1525. Pen and ink. 137 × 209 mm. British Museum, London (1859-6-25-544).

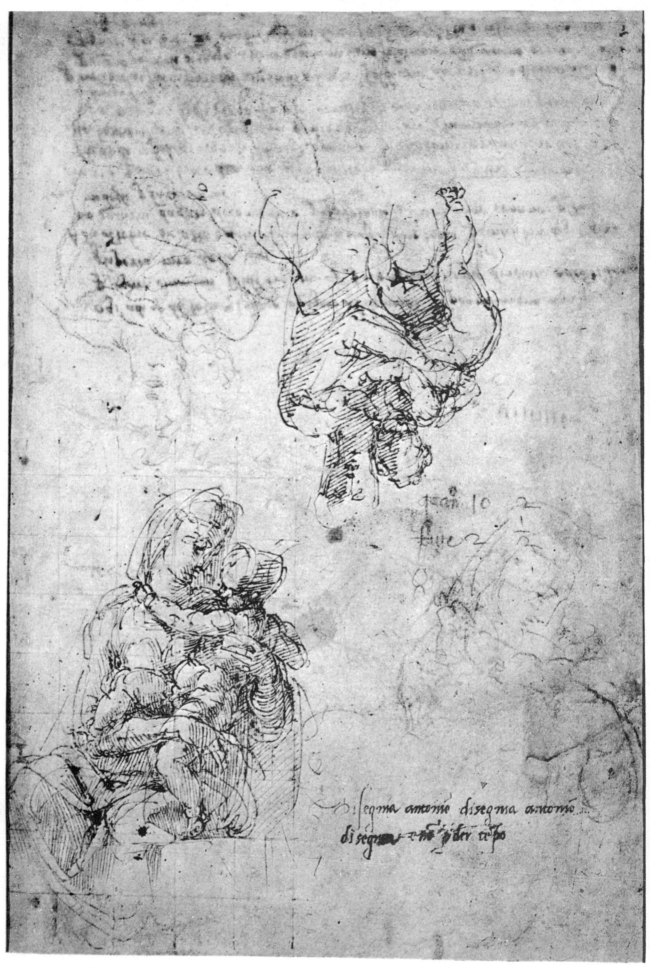

20. Two sketches of the Madonna and Child. Ca. 1524. Pen and ink. 396 x 270 mm. British Museum, London (1859-5-14-818 recto). The fainter sketches are copies of the pen versions by Michelangelo's pupil Antonio Mini.

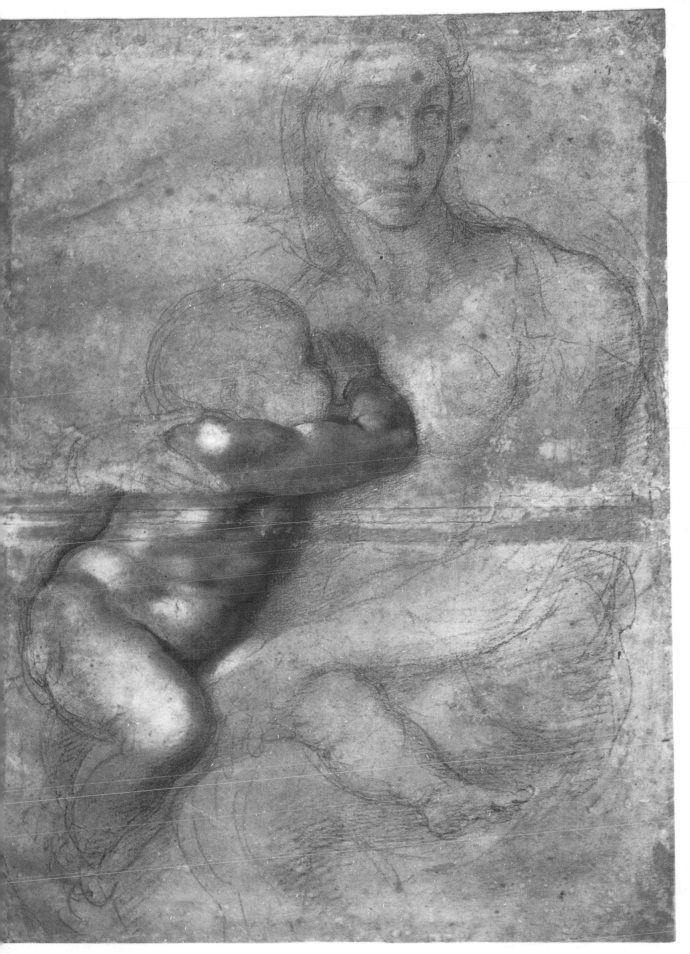

21. Madonna and Child. Ca. 1522. Black, white and red chalk. 541 x 396 mm. Casa Buonarroti, Florence (71F).

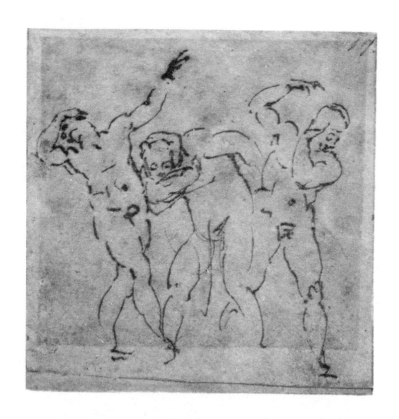

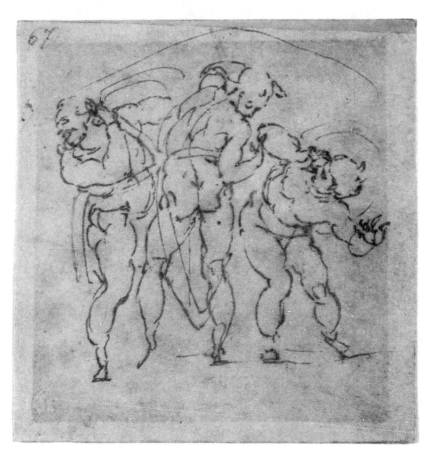

22. Figure studies. Ca. 1531–32. Pen and ink. Casa Buonarroti, Florence. ABOVE: 95 x 91 mm (17F). BELOW: 110 x 116 mm (67F).

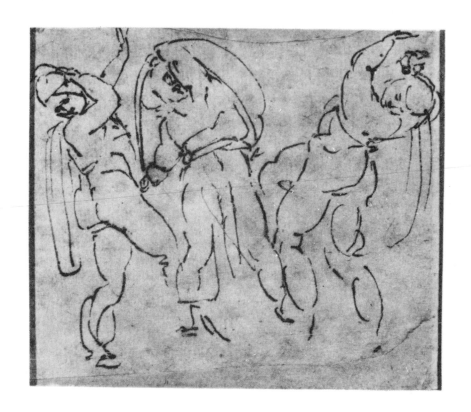

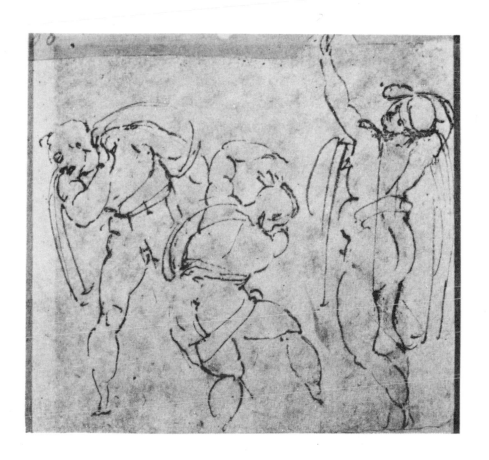

23. Figure studies. Ca. 1531–32. Pen and ink. Casa Buonarroti, Florence. ABOVE: 88 x 106 mm (18F). BELOW: 101 x 110 mm (68F).

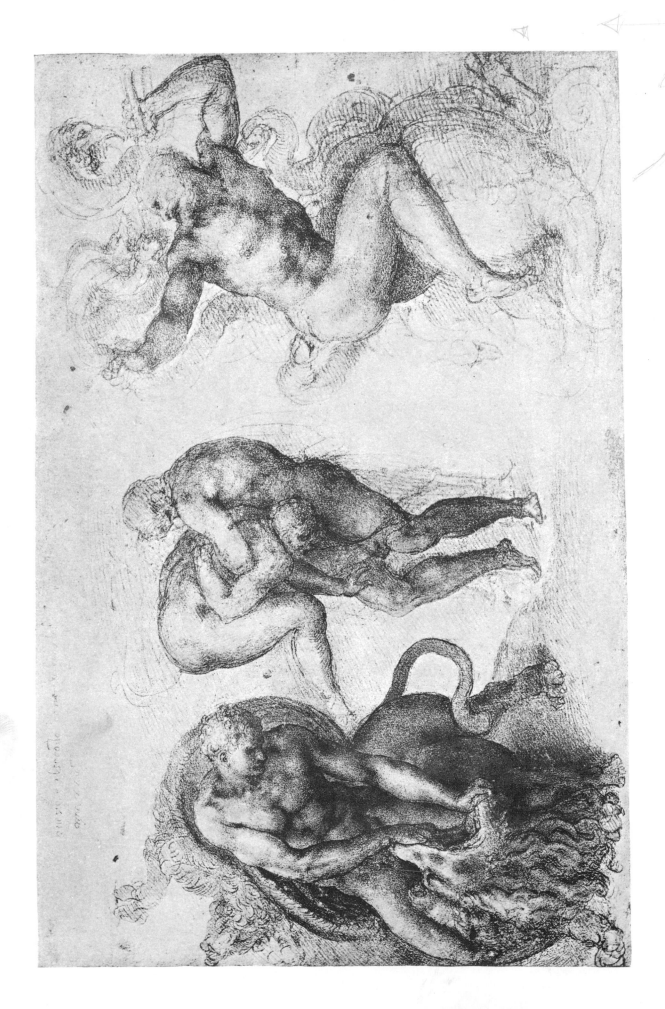

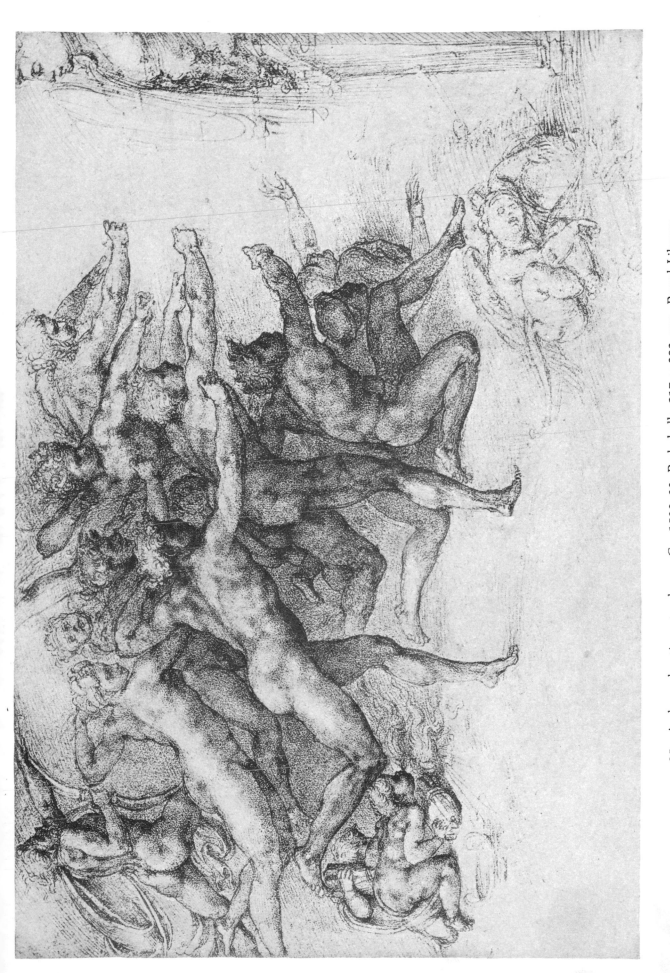

25. Archers shooting at a herm. Ca. 1530–33. Red chalk. 217 x 323 mm. Royal Library, Windsor Castle (12778).

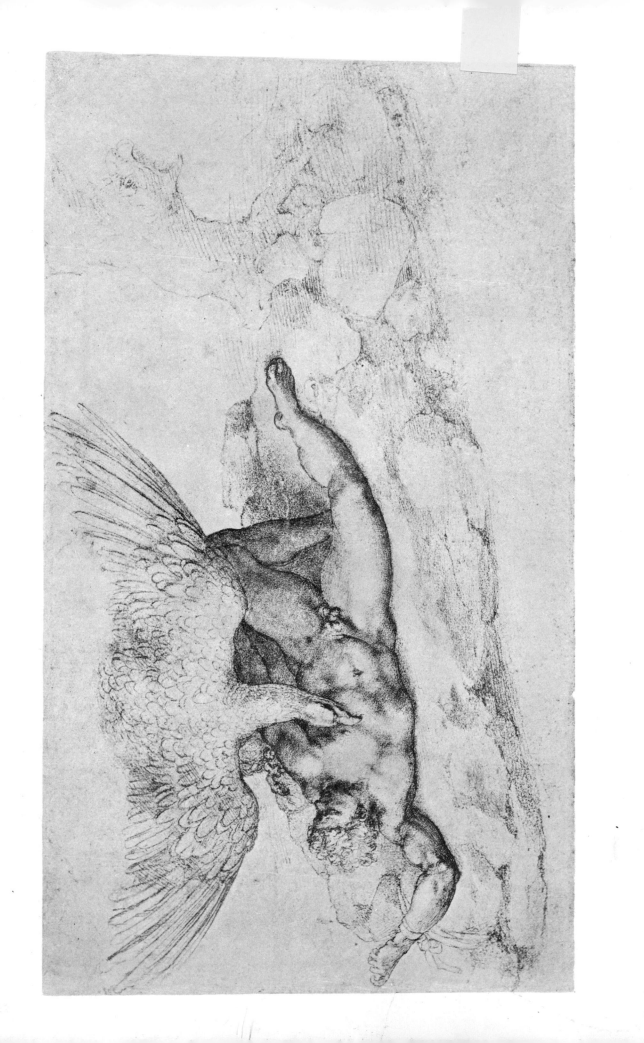

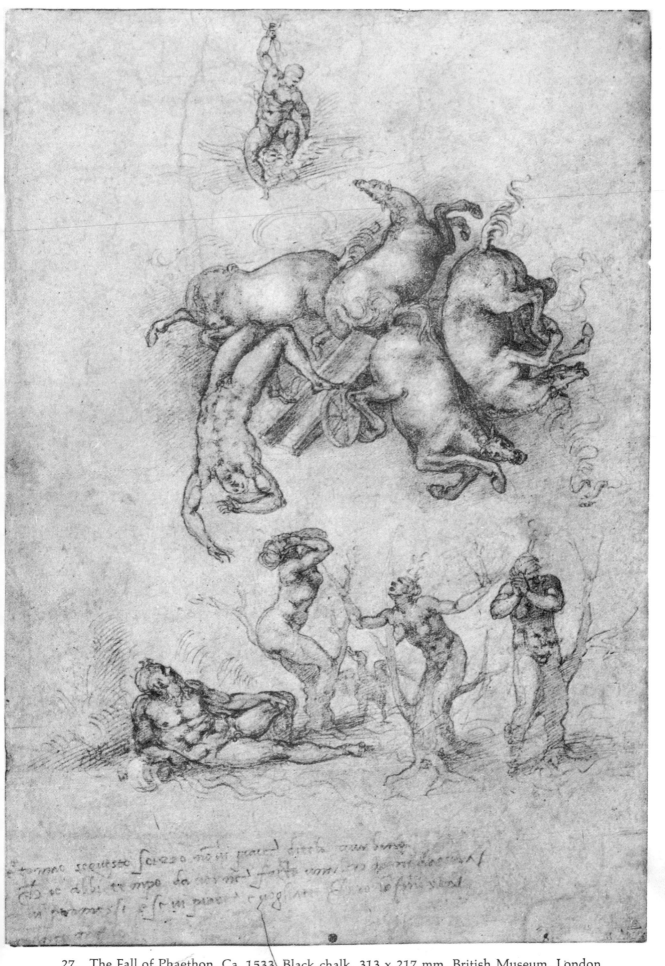

27. The Fall of Phaethon. Ca. 1533. Black chalk. 313 x 217 mm. British Museum, London (1895-5-15-517).

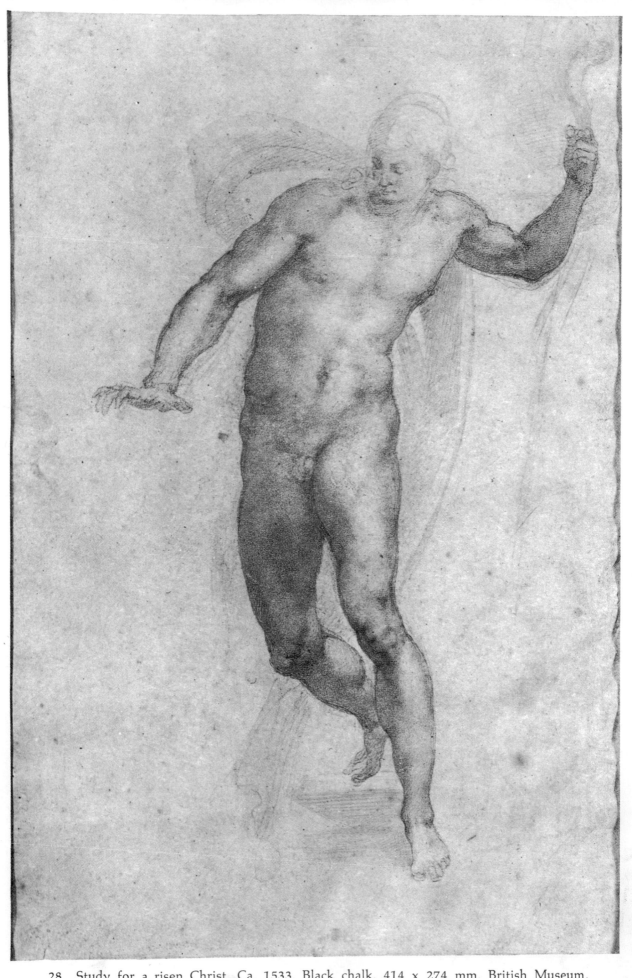

28. Study for a risen Christ. Ca. 1533. Black chalk. 414 x 274 mm. British Museum,
London (1895-9-15-501 recto).

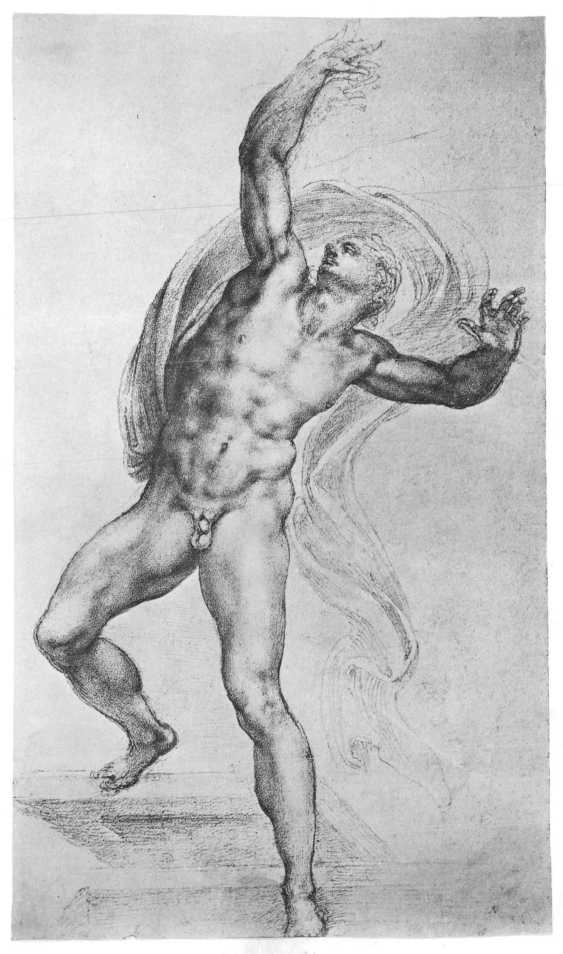

29. The risen Christ. Ca. 1533. Black chalk. 367 x 220 mm. Royal Library, Windsor
Castle (12768).

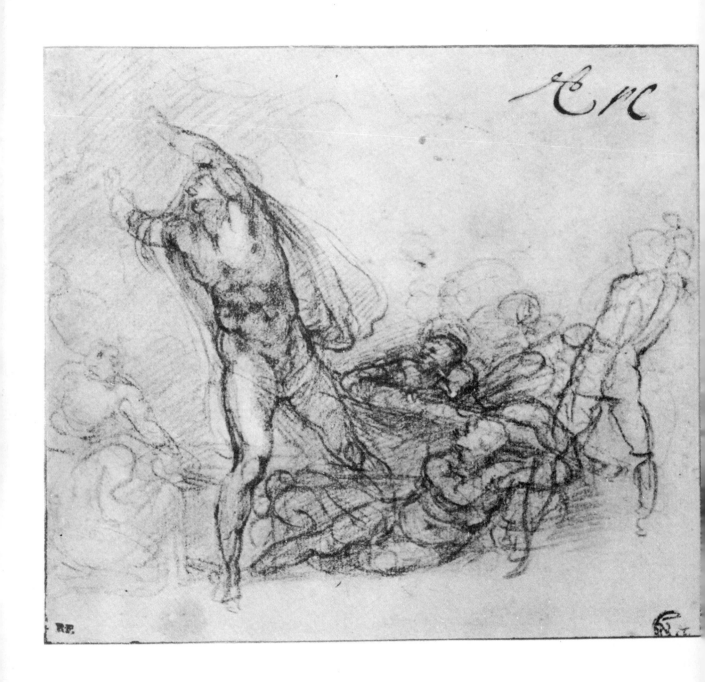

30. Study for a Resurrection of Christ. Ca. 1532–33. Red chalk. 155 x 171 mm. Louvre,
Paris (691b).

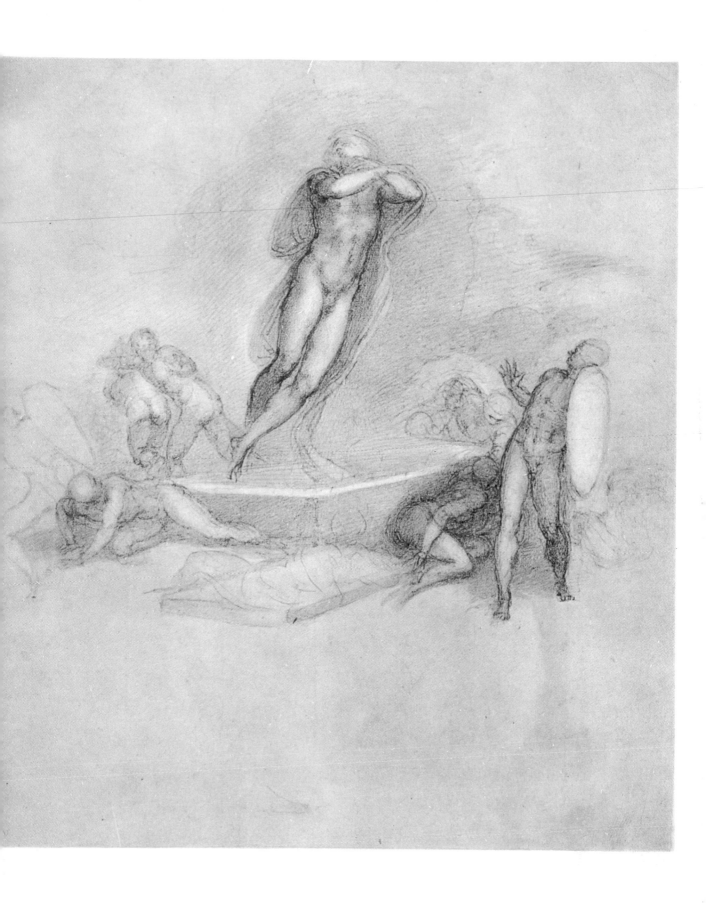

31. Resurrection of Christ. Ca. 1532–33. Black chalk. 326 x 286 mm. British Museum, London (1860-6-16-133).

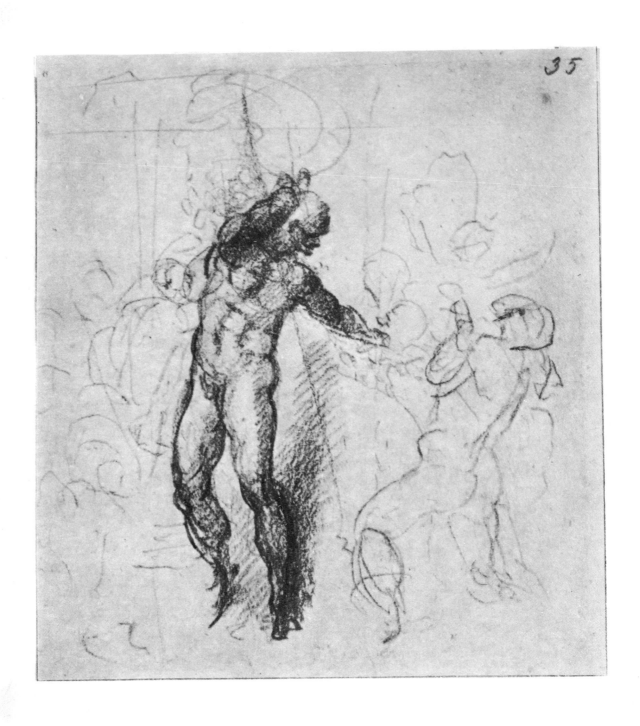

32. Study for a Christ in Limbo. Ca. 1532–33. Red and black chalk. 163 x 148 mm. Casa Buonarroti, Florence (35F).

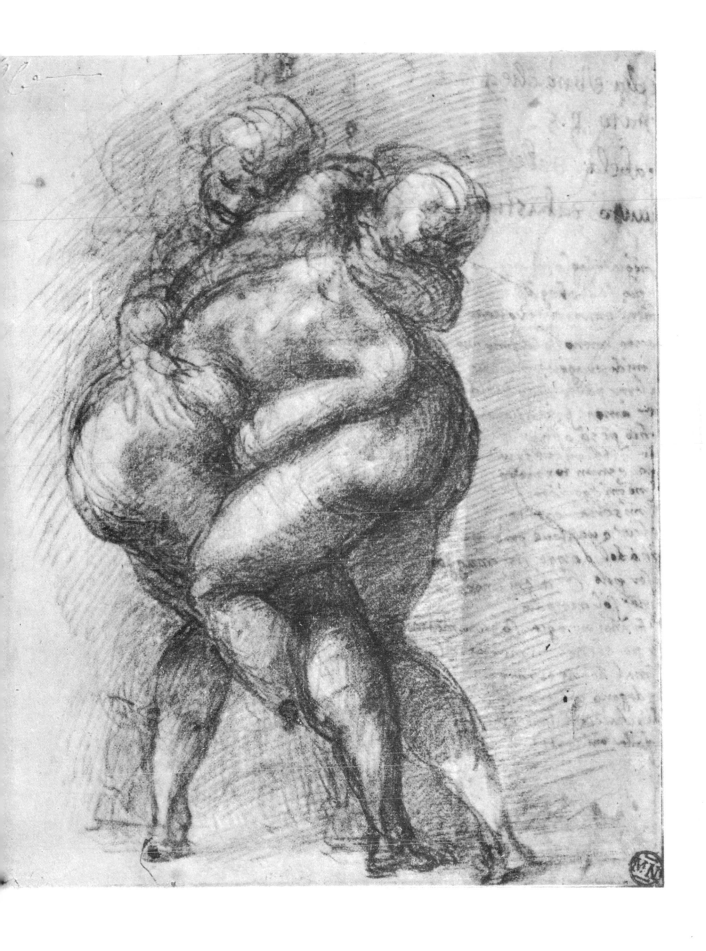

33. Men wrestling. Ca. 1530. Red chalk. 237 x 190 mm. Louvre, Paris (709).

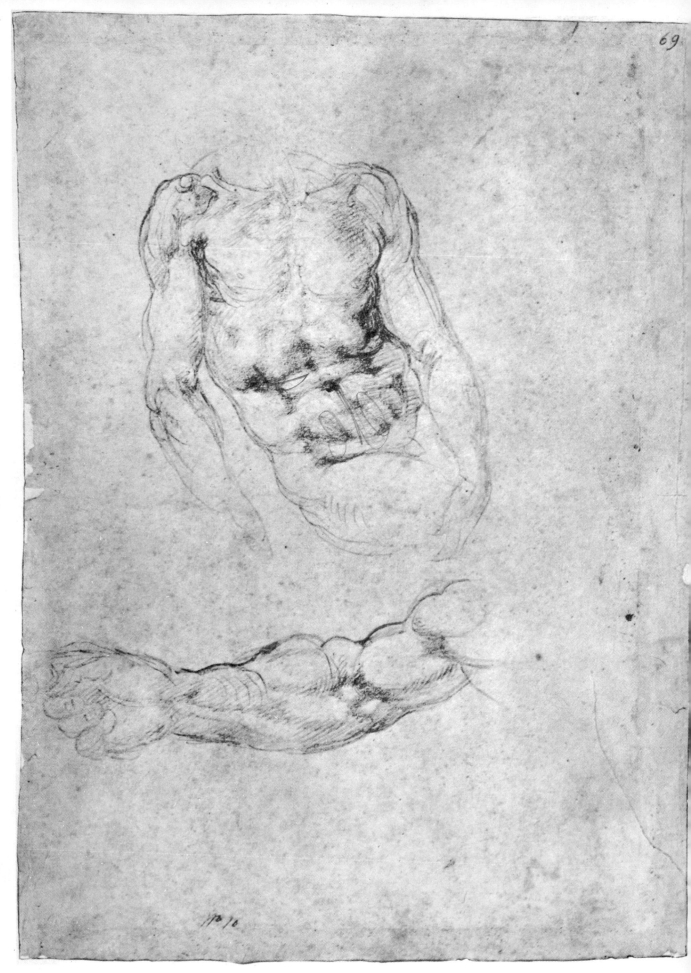

34. Studies for a Pietà or for *The Last Judgment*. Ca. 1525–35. Black chalk. 398 x 282 mm.
Casa Buonarroti, Florence (69F recto).

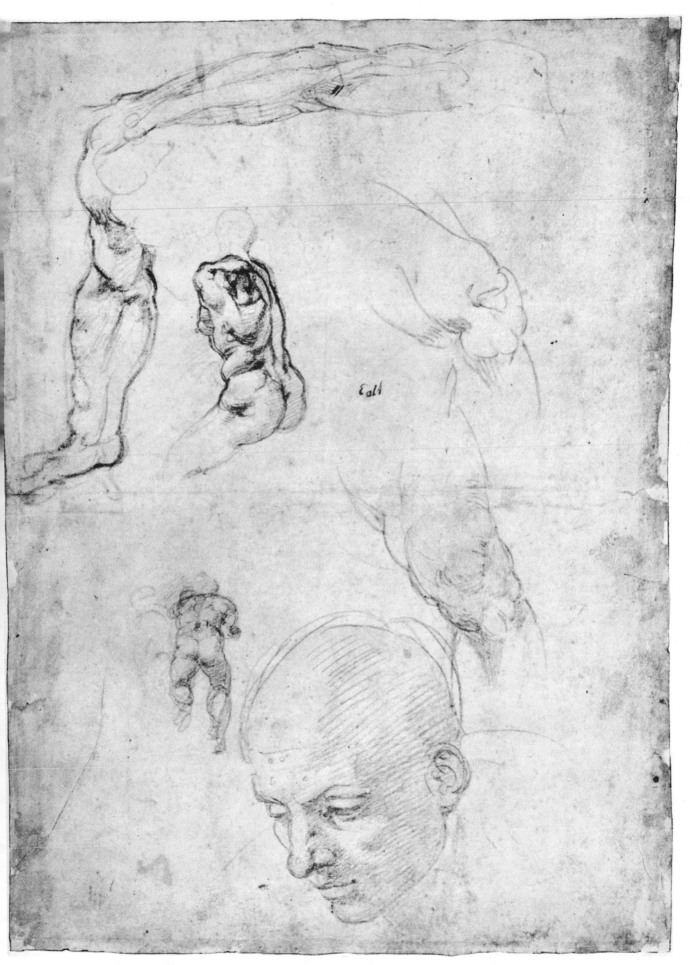

35. Studies for *The Last Judgment*. Ca. 1534. Black chalk. 398 x 282 mm. Casa Buonarroti, Florence (69F verso).

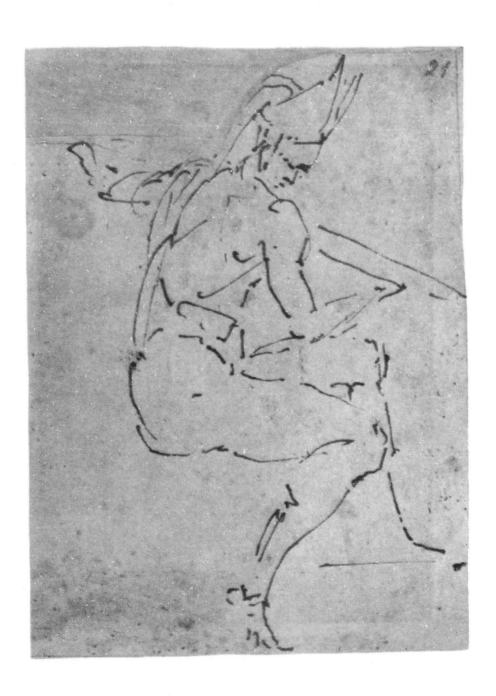

36. Seated figure (a pope?). Ca. 1531–32. Pen and ink. 157 x 114 mm. Casa Buonarroti, Florence (21F).

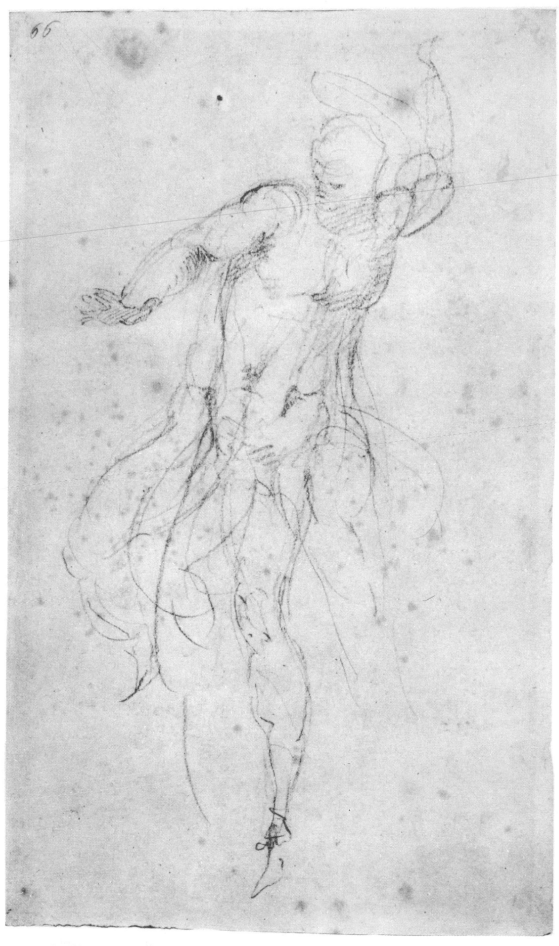

37. The risen Christ. Ca. 1532–33. Black chalk. 331 x 198 mm. Casa Buonarroti, Florence
 (66F).

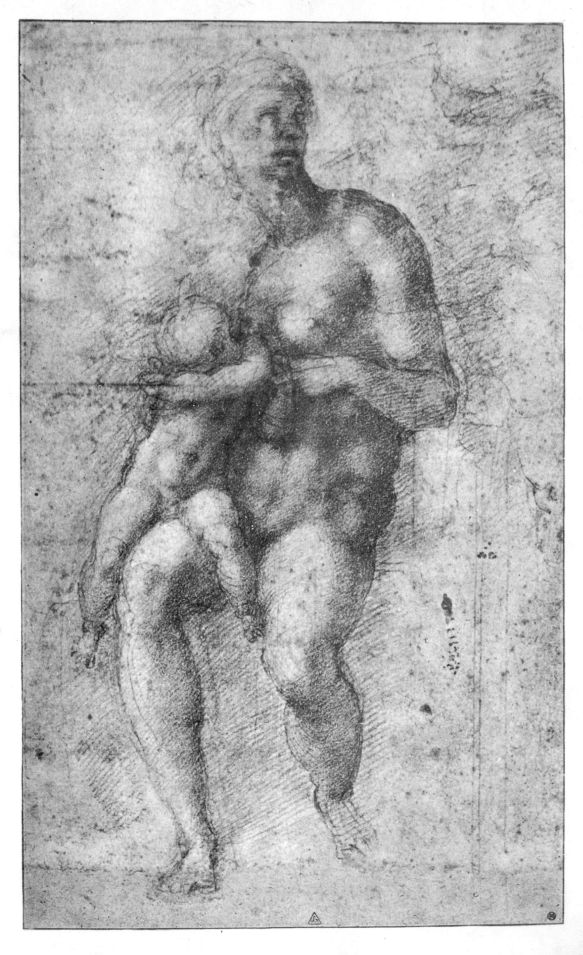

38. Study for a Holy Family with the Infant St. John. Ca. 1533–34. Black chalk. 317 x 191 mm. British Museum, London (Pp. 1-58).

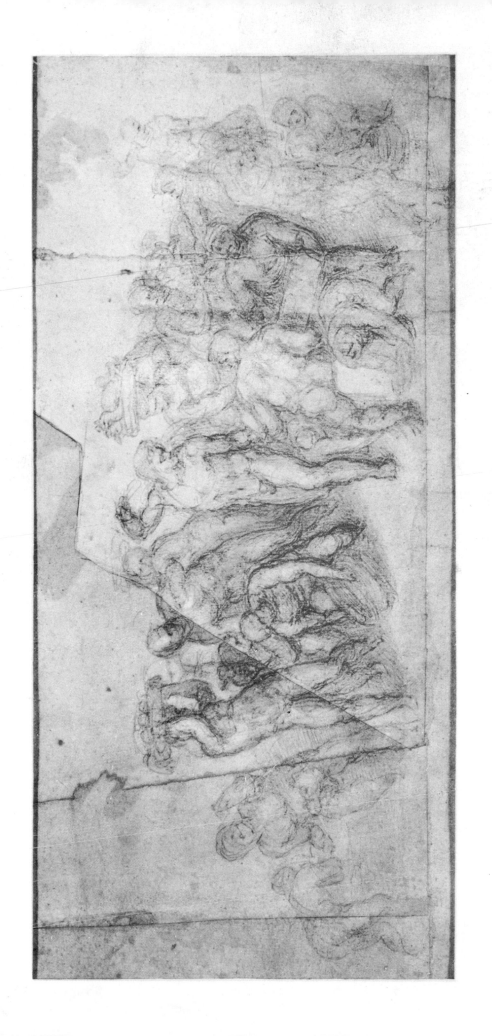

39. Study for a Christ Expelling the Money Changers. Ca. 1540–50. Black chalk. 178 x 372 mm. British Museum, London (1860-6-16-2/3 recto).

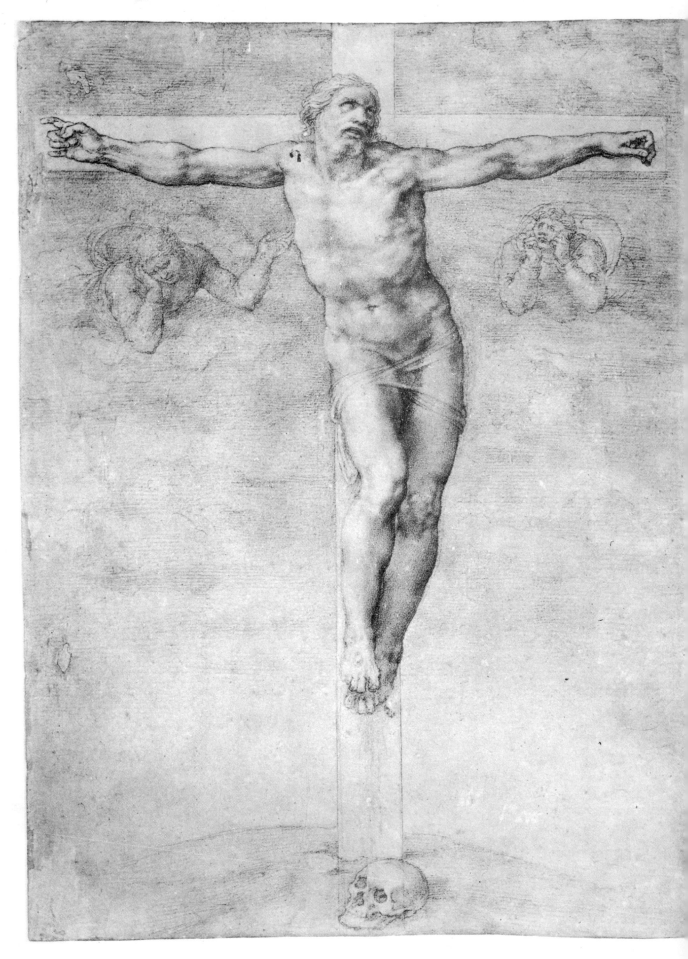

40. Christ on the Cross. Ca. 1540–41. Black chalk. 370 x 270 mm. British Museum, London (1895-9-15-504).

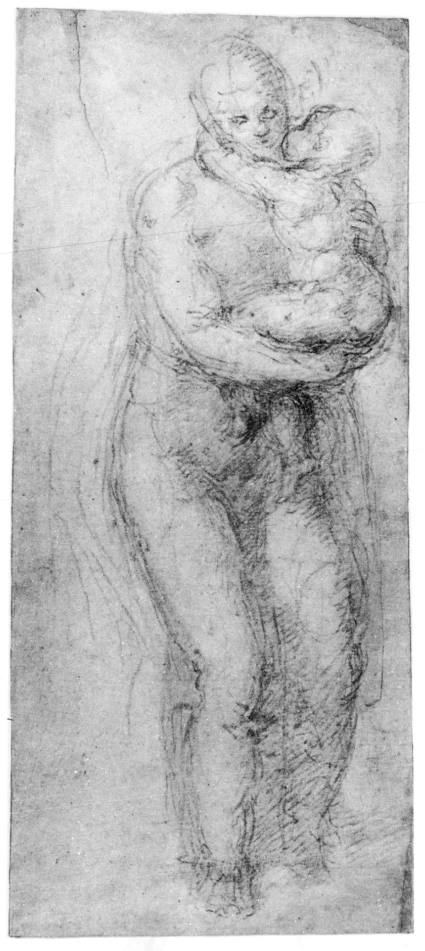

41. Madonna and Child. Ca. 1560. Black chalk. 266 x 117 mm. British Museum, London
 (1859-6-25-562).

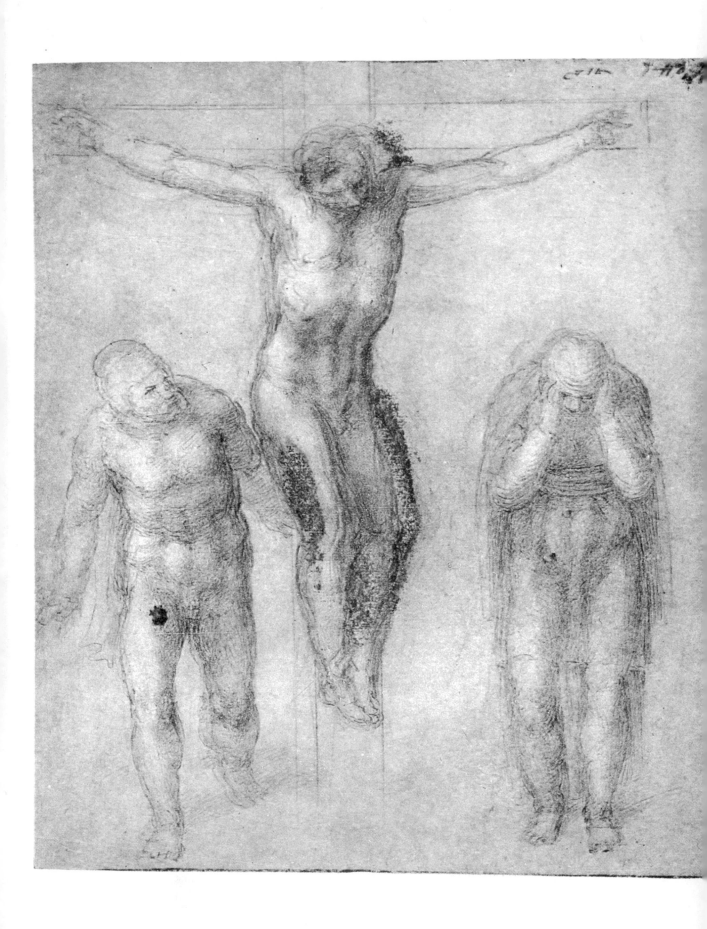

42. Study for a Christ on the Cross with Mourners. Ca. 1546–58. Black chalk and white lead. 278 x 234 mm. Ashmolean Museum, Oxford (72 recto).

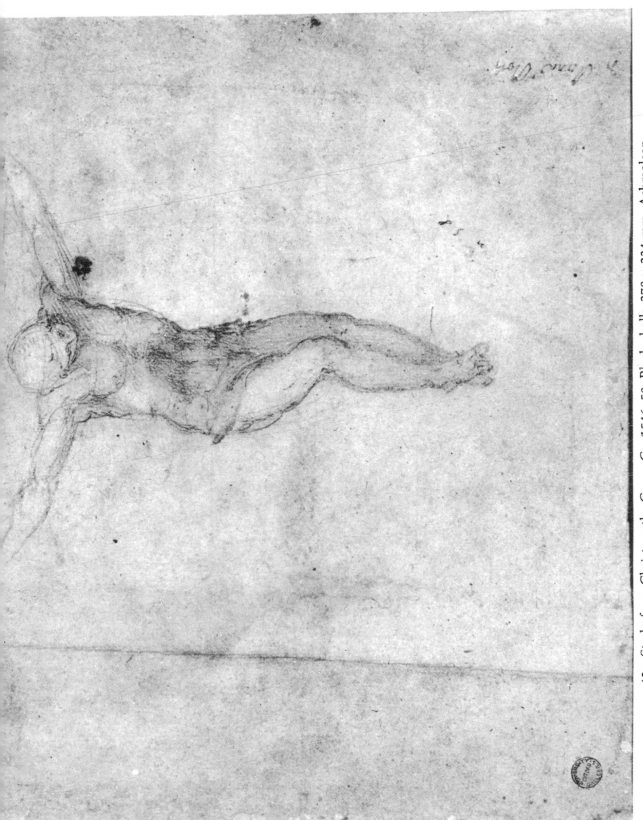

43. Study for a Christ on the Cross. Ca. 1546–58. Black chalk. 278 x 234 mm. Ashmolean Museum, Oxford (72 verso).